VIENNA 1900
THE VIENNESE SECESSION

©2006 Assouline Publishing
601 West 26th Street, 18th floor
New York, NY 10001, USA
Tel.: 212 989-6810 Fax: 212 647-0005
www.assouline.com

Color separation: Gravor (Switzerland)
Printed by *Partenaires Book®* (JL) (France)

ISBN: 2 84323 817 X

VIENNA 1900
THE VIENNESE SECESSION

FRANÇOIS BAUDOT

ASSOULINE

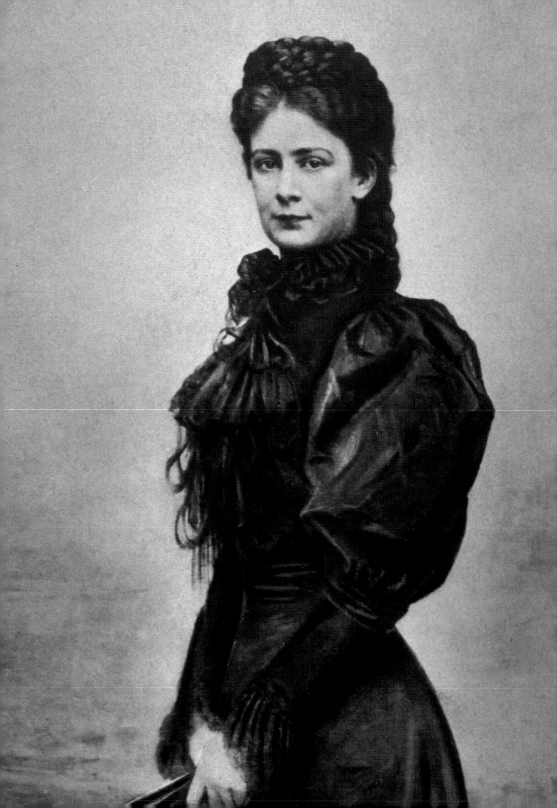

"The thought of death purifies, like a gardener weeding his garden. But this gardener wishes always to be alone and is annoyed when curious people look over his wall. That is why I hide my face behind my parasol and my fan, so that the thought of death may do its gardening undisturbed." So spoke Elizabeth of Bavaria, empress of Austria, in 1900. She was one of the most beautiful and glamorous women of her day. Her legend is inseparable from that of a glittering Austrian court, overjoyed with itself. Maurice Barrès wrote that Sissi's words constituted "The most astonishing nihilist poem we have ever known in these climes."

Portrait of Empress Elizabeth shortly before the death of her son Rudolf, 1889. © Cyrille Boulay/Corbis Sygma.

The year, 1900. Europe was about to break with the past, and it would continue to proclaim its independence throughout the twentieth century. The word "modern" was a war cry, defying the lessons of classical antiquity. It would accompany and justify every aesthetic battle, as the world of yesterday sank into the certainty of its own annihilation.

However, in 1900 the bourgeoisie was still trying to ape the aristocracy and did not for a moment doubt its future, nay, its destiny. The Parisians called this the Belle Epoque as, with amused skepticism, they surveyed the flourishes of an Art Nouveau that would soon be renamed "the noodle style." Pastiche, *pompier* academic art and historicism reigned supreme over the aesthetics of a Europe without frontiers, where the franc was tender all the way to Moscow. "Life's decor was so rich, so varied, and so overwrought," observed Thomas Mann in 1905, "that it left no room for life itself."

and yet, during the last decades of the nineteenth century, a subterranean current of contestation was already carrying minds towards greater simplification and formal simplicity. The cradle of this new aesthetic ambition lay over the English Channel. John Ruskin, William Morris, Charles Robert Ashbee, and even more singularly, the Scot Charles Rennie Mackintosh, all argued for a return to the innocence of earlier ages—to a Middle Ages that was nine parts fantasy but whose crafts offered an alternative to the obscene and chaotic luxury of the Victorian era. This small English group that emerged in the 1870s now reached outward to Belgium, the Netherlands, and Scandinavia. Without crossing paths with Louis

Majorelle or Emile Gallé, the pioneers of the School of Nancy, whose own aesthetic experiments were headed in a more Baroque direction. It was Vienna that reacted most favorably to this reforming spirit which aspired to create a total art that would synthesize all the different creative disciplines, and which advocated beauty for all. This was the utopia underlying all the great design experiments of the twentieth century.

Vienna in 1900 was home to a multitude of creative talents. Together, they would give shape to the city's distinctive form of modern art. And this deep-rooted process was itself inseparable from the history of the Austro-Hungarian Dual Monarchy. In the sixteenth century, Charles V could boast that the sun never set on his possessions. And even in its reduced form, after the fall of Napoleon and the Congress of Vienna, the empire he left remained astonishingly diverse, peopled by Italians, Germans, Czechs, Hungarians, Slovaks, and Croatians.

In 1874, the oath of loyalty sworn by the soldiers of the emperor Franz-Joseph was still printed in eleven different languages. And no city offered more cultural opportunities than his capital, the most populous in Europe after Paris. A mixture of mistrust and empathy, the pull of the former Holy Roman Empire was felt in diplomatic circles throughout Europe.

Austrian cosmopolitanism was also a remarkable breeding ground for new ideas. Paradoxically, it was just as the real power of its aged emperor had begun to wane, and when the dangers were accumulating at its frontiers, that, in the short period from 1890 to 1920, Austria would preside over the birth of a new temporality.

The process was all the more unique in that it prefigured the collapse of a monarchy dating back hundreds of years and the onset of an unprecedented historical tragedy. "Historically, only periods of decline are captivating, for it is at such times that the questions of existence in general, and of history itself, are really posed," notes Emil Cioran. Perhaps, then, the interest of Gustav Klimt's painting, of Josef Hoffmann's formal experiments, and of the productions of the Wiener Werkstätte is to be found precisely in this fragile equilibrium between a certain appetite for life and the spectacular mourning for lost glory.

"It is difficult to measure yourself against a social order that exists, but it is even harder to have to elude one that does not exist," wrote the poet Hugo Von Hofmannsthal, who wrote the librettos for composer Richard Strauss. In his town of Vienna, the opera was directed by Gustav Mahler, while Sigmund Freud had commenced the lonely task of exploring the enigmatic paths of a new understanding of the human psyche. Here Arthur Schnitzler and Stefan Zweig were publishing, and Otto Wagner was presiding over "the free renaissance of the art of building" and celebrating the city as the acme of modernity, while his pupil, Josef Hoffmann, was laying the foundations of a new ethos of architecture and the decorative arts. Meanwhile, Hoffmann's alter ego, Koloman Moser, directed Viennese workshops that were designing art objects for a mass public and revitalizing crafts that a century of industrial production had pushed to the margins. Here lived the writer Peter Altenberg, one of the most typical representatives of what was known as Viennese Impressionism;

Theodore Herzl, the philosopher and prophet of political Zionism, who advocated the then utopian idea of an authentic Jewish state; the writer Robert Musil, that "vivisectionist of the human soul;" and the philosopher and mathematician Ludwig Josef Wittgenstein, who was himself close to the architect Adolf Loos, the author of *Ornament and Crime*, who was a friend of Tristan Tzara, the prophet of Dadaism. Vienna was home to Alban Berg, Carl Moll, Dagobert Peche, Hermann Broch, Wilhelm Reich, Joseph Roth, Arnold Schönberg, Fritz Lang, Frantisek Kupka, Manes Sperber...and this is far from a complete Who's Who of all those who were challenging and radically renewing every creative and intellectual sphere in turn-of-the-century Vienna. In that "monstrous residence of a king who was already dead and of a god who had yet to be born," as Hofmannsthal himself put it.

a ghost in this Austria of shadow and light, wife to the emperor since 1854, now sardonic, disillusioned, and cut off from reality, but lucid in her despair, Elisabeth von Wittelsbach witnessed the end of a world that she continued, if not to love, then at least to haunt. Her legendary mental insta-bility and the frenetic wanderlust that took her from one country to another somehow made her the precursor of that neurotic divaga-tion afflicting those profoundly uprooted individuals whom psychoanalysis was now setting out to study. Freud, whose medical career had failed to deliver the success he was hoping for, withdrew in 1895 in order to test his theory of the analytical cure, articulated around the Oedipus complex, and to work on the interpretation of dreams. At about this time, and in a rather similar manner, the hitherto rather academic artist Gustav Klimt

began experimenting with a new way of painting. Giving up any pretence of realist description, he adopted a space without depth and, like other contemporaries including the Nabis, referred to Japanese painting. The twists of his irregular figures are wholly dictated by their erotic or morbid symbolic function. We might regret the fact that the painter and the inventor of psychoanalysis never met, living as they did in the same city. But then in that same period, Stéphane Mallarmé and Gustave Moreau were living on opposite sides of the railway at Saint-Lazare in Paris, and neither crossed the tracks to meet his fellow creator. Still, the simultaneity of the respective explorations undertaken by Freud and Klimt does say a great deal about community of thought in the Viennese intellectual concert. While, like its own underground world, the empire was becoming increasingly indifferent to what went on outside, its intellectual elite had withdrawn into itself and ignored the manifest decay. It sought refuge in introspection and in the annexation of fields still alien to the world of the mind—things like the unconscious and inner life, which propriety had always insisted on leaving unspoken, if not simply ignored.

While Viennese high society danced to the tunes of the *Fledermaus*, still confident in its power over the outside world, Gustav Klimt, his student Egon Schiele, and other great artists of the day set out to probe those abysses that were the sex and death drives. Like Freud, Klimt took a great interest in ancient history and in archaeological excavations of which numerous symbols can be found in his monumental decorative, almost abstract style. As for woman, who occupies the center of Klimt's work, her different facets express all the possibilities

of desire, pleasure, suffering, and sin. In his paintings, elegiac happiness alternates with images of morbid passion.

born in 1862, the son of a gold and silver engraver, Klimt graduated from the Vienna School of Decorative Arts in 1883. Primarily a muralist—although his portraits, landscapes, and above all, pencil drawings evince a boldness that looks ahead to the art of the future—he had a gift for handling volumes as complete wholes and for collaborating with architects. Witness the Stoclet House, the only surviving example of the dialogue between Klimt, Hoffmann, and Moser. The exuberant scale of the paintings and the graphic conception produced by Klimt's protean genius can often mislead us as to the real scale of some of these enigmatic works with precious inlays of ceramics, gold leaf, colored glass, and enamel. "Gustav Klimt, you are at once a visionary painter, a philosopher, and a modern poet. When you paint, you metamorphose, as in a fairy tale, into a man of the greatest modernity," wrote Altenberg in his short prose sketches, the many volumes of which offer a remarkably lively account of the richness of Viennese life at the turn of the century, especially in the cafés where writers and artists used to meet.

In 1897, impatient to break with the traditional values of the bourgeoisie and its art, Klimt left the very conformist Künstlerhaus ("House of Artists") and its academic doctrines and, with twoscore companions, created the Viennese Secession. The following year, the new movement built its own exhibition hall, a clean, geometric building surmounted by an openwork dome in wrought iron whose interlacing bay leaves were distinctly

Jugendstil, the term designated for Art Nouveau in Germany and Austria—but with a finesse, a refined use of squares, and right angles that distinguished Viennese art and kept it from the excess and dubious deliquescence that Jugendstil sometimes lapsed into elsewhere. This pagan temple, built under the aegis of Joseph Maria Olbrich to promote a new and highly aestheticised style of life, carries the motto "To each age its art, to art its freedom."

t he conception of the Secession was aristocratic; its effects were intended to be democratic and universalist. "We recognize no differences between great art and small, between the art of the rich and that of the poor. Art belongs to all." This idea may have been reprised a hundred times since, but at the turn of the century it was still profoundly subversive. Thus the Secession's most significant exhibitions were ensembles that featured displays of architecture, painting, sculpture, and applied arts (with a very rich output in textiles, jewels, fashion accessories, and ornaments for women and the home). The main organizers of these exhibitions, whose importance was long underestimated elsewhere in Europe, were Josef Hoffmann and Koloman Moser. As for Egon Schiele, the exhibition of his free, scandalous paintings in 1918, the year of his death, proved, in spite of its popular success, to be the final episode in this great collective adventure.

Born in 1890 in Tulln, not far from Vienna, Egon Schiele's shocking genius won him only posthumous popularity. Some have seen him as an artist "suicided by society," like Van Gogh before him. In fact, it was something much more prosaic, the Spanish flu epidemic, that took the life of this young bourgeois whose genius

had been spotted by Klimt when he was at the Academy of Fine Arts and who, like his elder—albeit in an infinitely more violent and obsessive way—was fascinated by the figure of woman. But however clearly, with hindsight, its poetry and extreme physical intensity can be seen to anticipate one of the major concerns of modern art, Schiele's work was misunderstood by most of his contemporaries.

Oskar Kokoschka (1886–1980) started out as one of the more elegant exponents of Jugendstil, but soon moved towards a raw eroticism, a revolt that would make him one of the masters of German Expressionism, both *enfant terrible par excellence* and long-lived master whose most pessimistic visions proved tragically prophetic. Passionately in love with Alma Mahler, the ravishing young widow of Gustav Mahler, his tormented and tragi-grotesque art is obsessed with the war of the sexes.

the protean talents, energy, and teacherly example of Koloman Moser (1868–1918) make him one of the most attractive figures of the Viennese Secession. He was also one of its key protagonists and, in many respects, its mainspring. At the age of 28 he started to give courses at the School of Decorative Arts, and also organized and edited *Ver Sacrum* (Sacred Spring), the movement's monthly journal, which published texts and illustrations by the Viennese avant-garde. Above all, however, he cofounded the Wiener Werkstätte with Josef Hoffmann in 1903. These crafts workshops represented a commercial experiment that has remained unique to this day for its production of everyday objects and gathering a highly diverse range of talents to produce furniture, ironwork, glass, ceramics,

jewelry, books, illustrations, and even postcards (which now fetch exorbitant prices from fanatical collectors). Even today, the profusion of all these crafts supported by elite taste is truly stunning. A particularly important mover here was the wealthy, liberal Jewish bourgeoisie, eager as it was to assert its identity and independence as a newly risen group with regard to the conventions of the fine arts. The most famous example of its involvement is the donation made by the industrialist Karl Wittgenstein—father of the philosopher Ludwig—which enabled the Viennese Secession to construct its pavilion in 1898.

t he other major figure of this Viennese flowering at the turn of the twentieth century, whose name has already been mentioned many times here, was the architect Josef Hoffmann. Born in 1870, he was spotted at the age of 20 by Otto Wagner, who is himself now considered one of the fathers of modernist architecture. If the fusion of artistic disciplines had been characteristic of Viennese cultural life ever since the Baroque era (opera being the most brilliant example), then Hoffmann was one of the greatest proponents of this striving for total artwork.

After working on the project for the Viennese underground system, he designed several exhibitions for the Secession, of which he was a founding member. He then began teaching the subjects of architecture, interior decoration, fashion, and enamel painting. In 1900 he worked on the Viennese Pavilion at the Exposition Universelle in Paris. Under his direction, the Wiener Werkstätte built a number of ensembles, such as a sanatorium and private housing, as well as public spaces. Not a single detail of these projects escaped the master's vigilance. His most remarkable ensemble is the house

built for the Belgian business magnate Stoclet in Brussels between 1905 and 1911. The project was executed quite free of financial limitations. Even today, one can still appreciate this attempt at a total artwork (Stoclet's heirs made few changes). Between 1923 and 1925, Vienna's Socialist government commissioned Hoffmann to design social housing. He designed the Austrian Pavilion at the Paris Exposition des Arts Décoratifs in 1925 and then at the Venice Biennale in 1934. The variety and abundance of the buildings and objects he created up until his death in 1956 deter any attempt to list them. It would be more apt to leave the last word to Josef Frank, who was himself one of the founders of the Deutscher Werkbund (through which avant-garde artists worked for industry), speaking on the occasion of Hoffmann's sixtieth birthday: "Modern architecture is indebted to Josef Hoffmann, not only for ridding it of the petrified historical forms whose weight was hampering new development, but also for bringing that lightness and transparency which are, it seems to us, its principal characteristics. Austria is indebted to Hoffmann for having based the renewal on Austrian tradition, by taking his inspiration from still existing monuments, and for having given it new values whose decisive influence spread beyond its frontiers and made itself felt around the whole world."

W here to turn: to a glorious past or to a future dominated by modernism? Standing on the brink of the dangerous twentieth century, Vienna, the capital of the Baroque, was truly Janus-faced. In this decaying empire, the fin de siècle mood tussled with the desire to explore the human soul and its undiscovered potential. The term "Secession" clearly tells us that this was a civil war—even if

waged only in the field of aesthetics. On one side, a carefree attitude set to the music of waltzes by Richard Strauss, Franz Lehár, Franz Von Suppé, and other masters of dance; on the other, more intimate concerns and conflicts, the exploration of a mental world that has concerned all conscious Europeans ever since.

U nlike most other avant-gardes, the Viennese artists and intellectuals of 1900 were not revolutionaries: rather, to paraphrase Goethe, their goal was to build a better future by extending elements from the past. And perhaps that is what makes them so meaningful for us today, at the dawn of this third millennium. The biblical words of Brahms's *German Requiem* remind us that "All flesh is as grass, and all the glory of man as the flower of grass." Freud, Schnitzler, and the great Viennese painters were the first to show that human nature is governed by Eros and Thanatos. The deaths at Mayerling, the tragic end of Sissi, and the collapse of the Viennese Secession itself vividly demonstrated this reality, at both its worst and its best. And that is what makes this brief interlude so appealing, for it was a time when, like Mahler, one could write unforgettable songs about the death of a child, and when men could lavish care on the design of a plate or the form of a lamp. And by that lamp we can read the story of what followed.

Post-scriptum: In 1908, Adolf Loos (1870–1933), one of the fathers of modernism as we now understand it, and one of Le Corbusier's masters, published *Ornament and Crime*, a broadside reflecting his belief in the need to free architecture from the obligation of decoration, and expressing his loathing of Hoffmann and the Wiener Werkstätte. Loos was the purist of the new movement, who gave us the maxim "Ornament is crime." Since then, history has taught us all about the dangers of purity. Still, Loos was, in spite of himself, a son of fin de siècle Vienna, and his contribution to the modern age was essential.

In 1949, Vienna was only the capital of an occupied country, its sewers haunted by traffickers later memorably embodied by Orson Welles in *The Third Man*. A hundred thousand Jews met their death here. Strange flowers grow from that tomb, and in their odor are many things we still need to learn.

La Bastide du Cap Nègre, August 2005

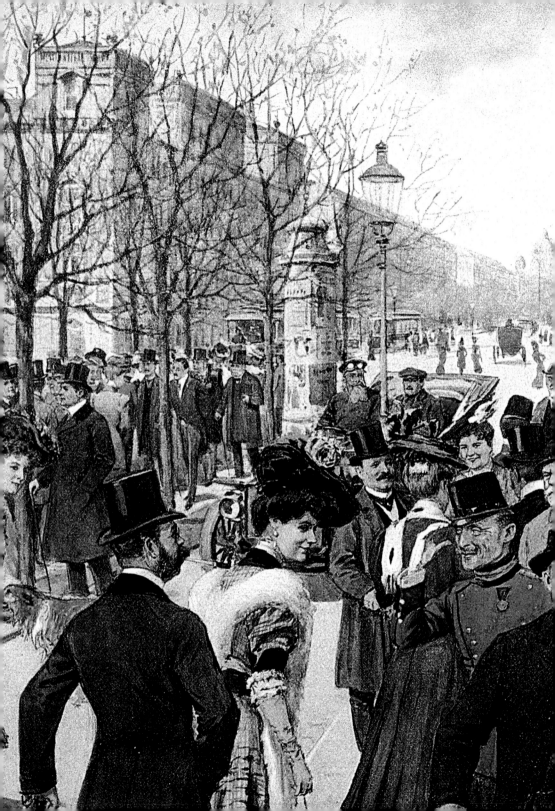

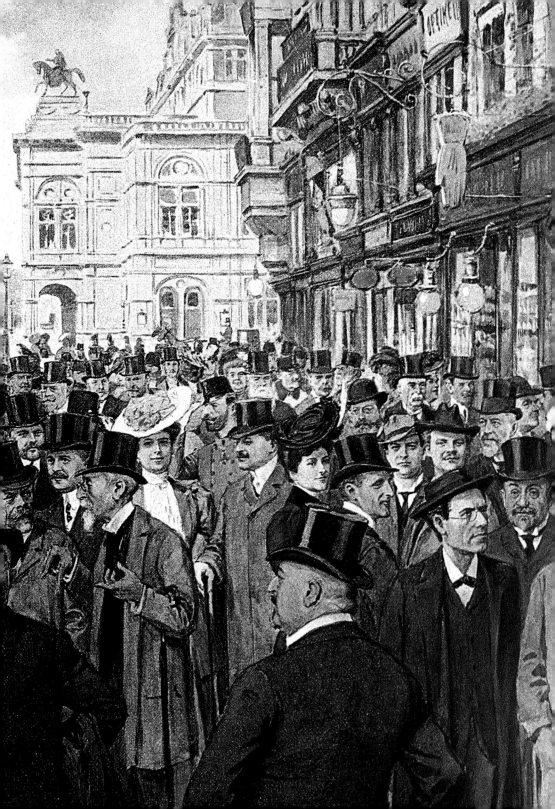

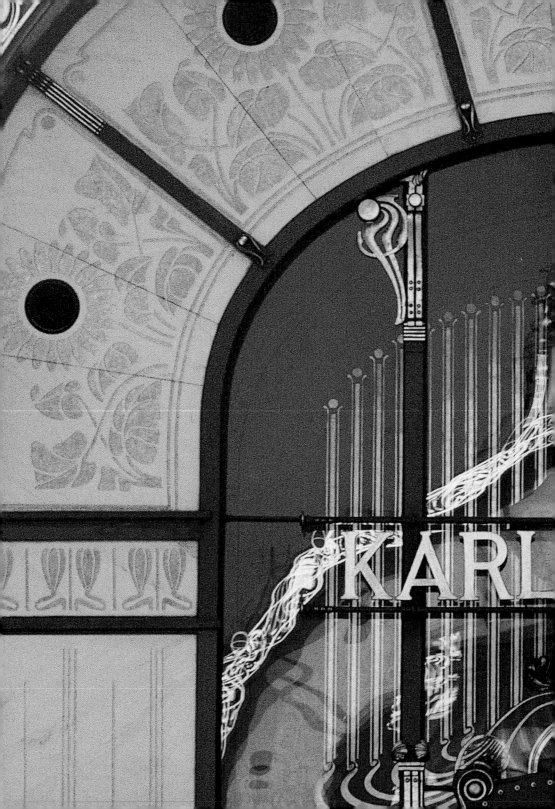

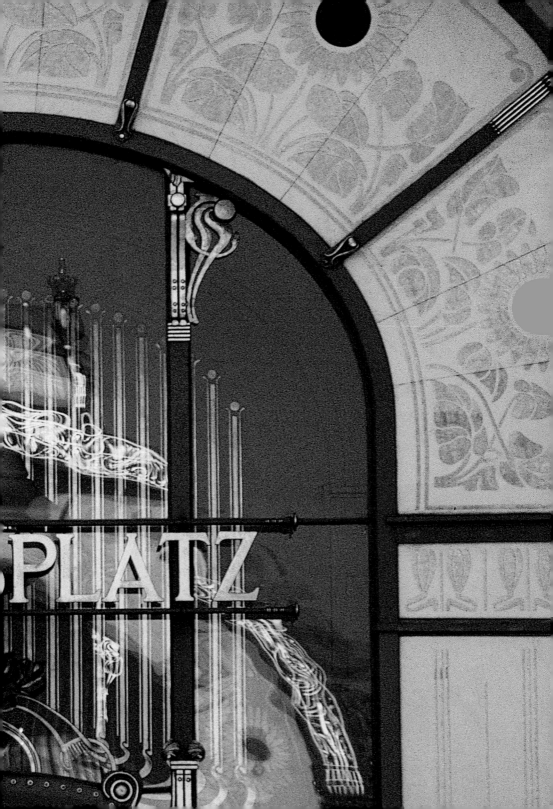

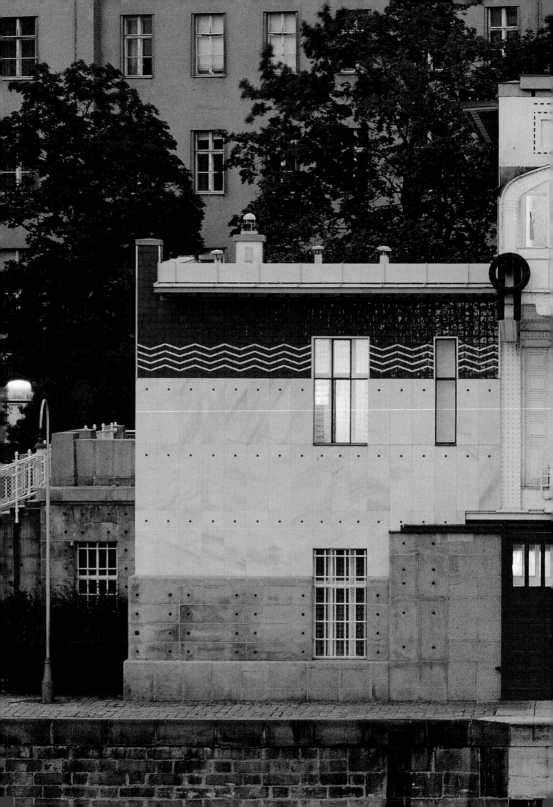

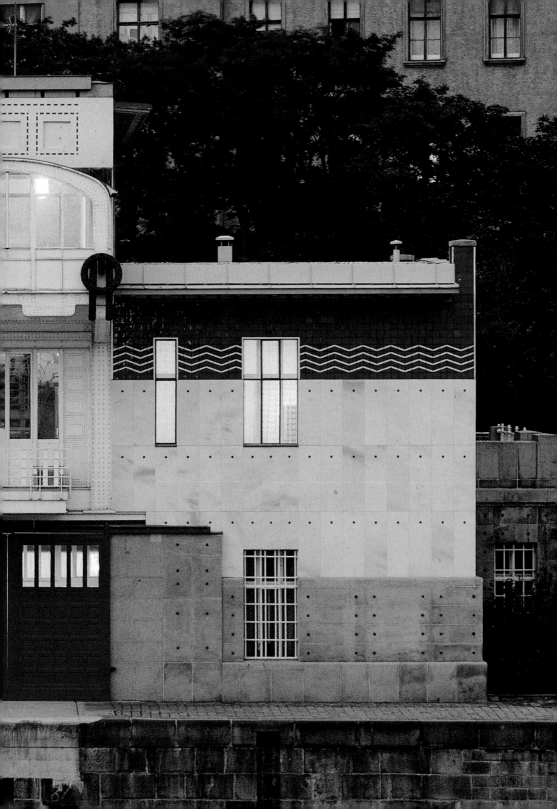

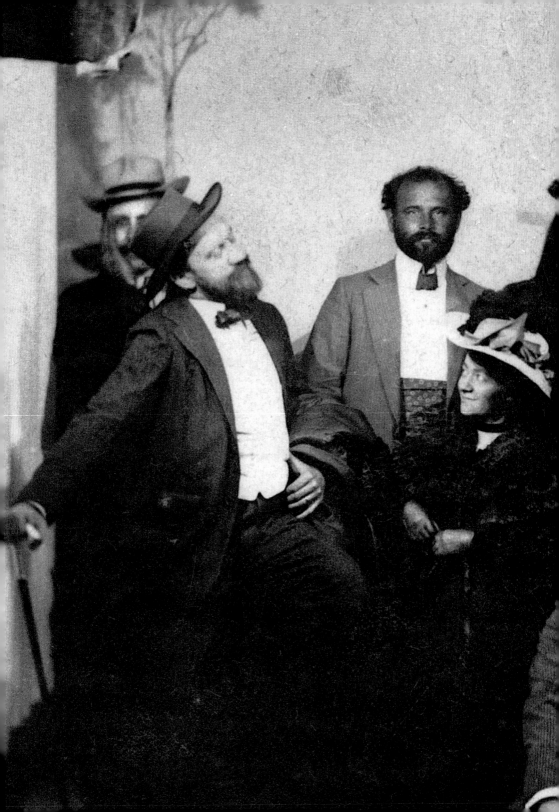

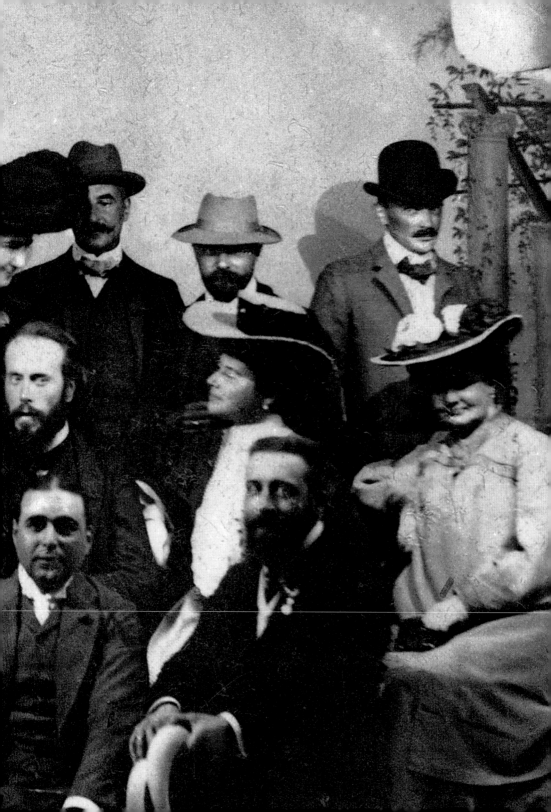

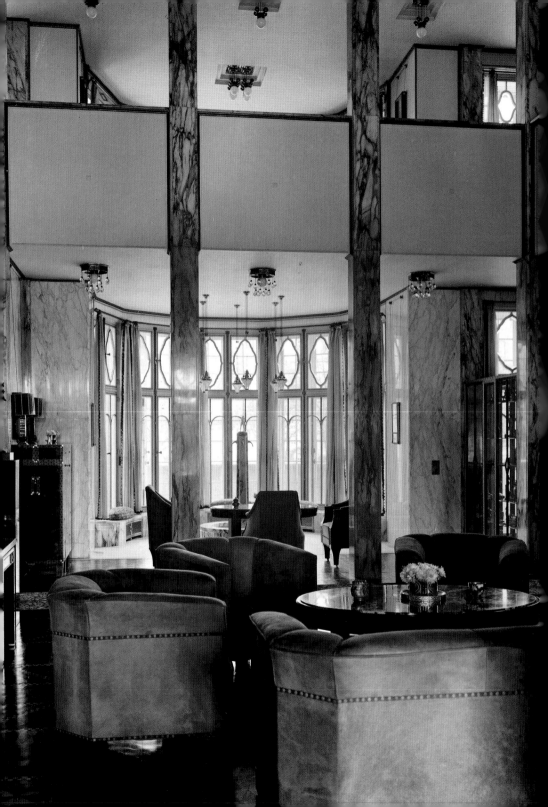

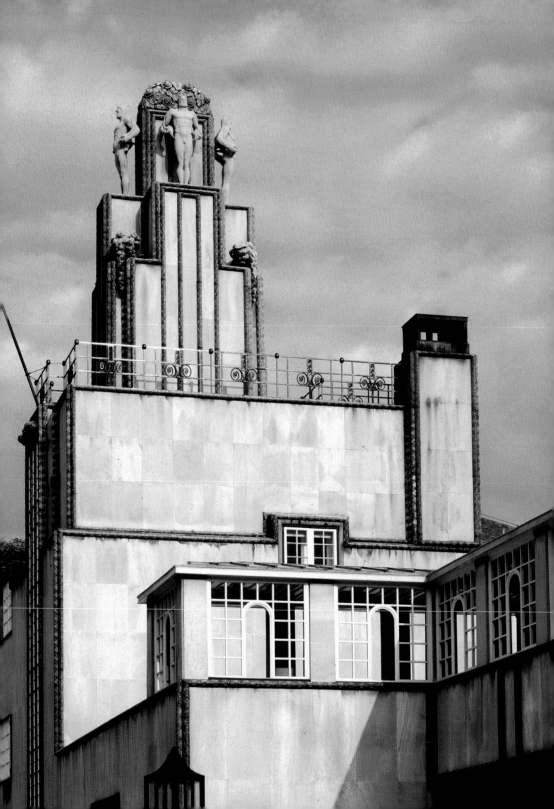

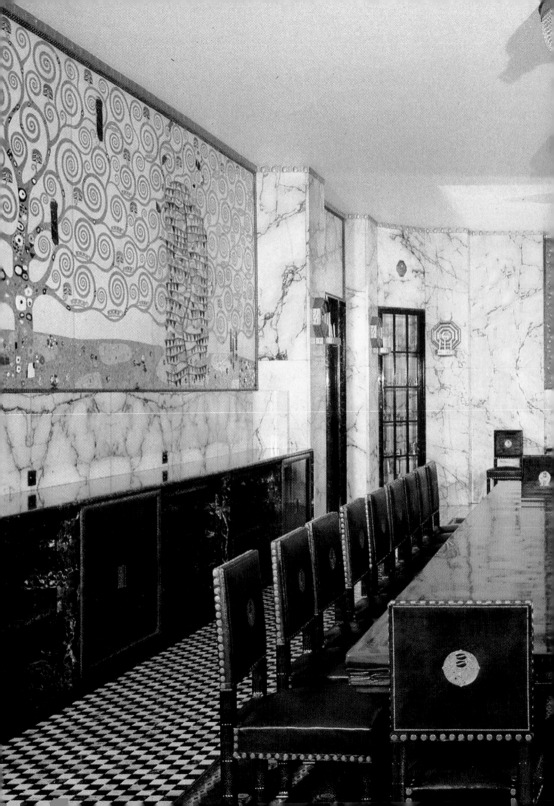

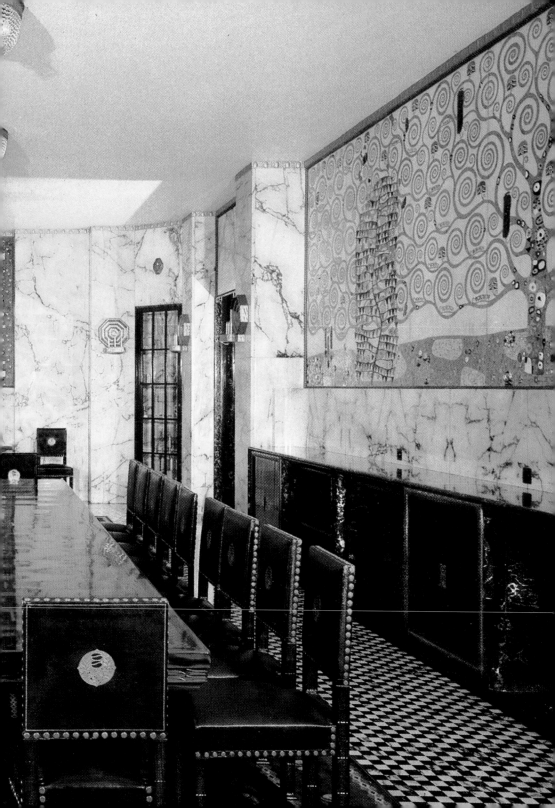

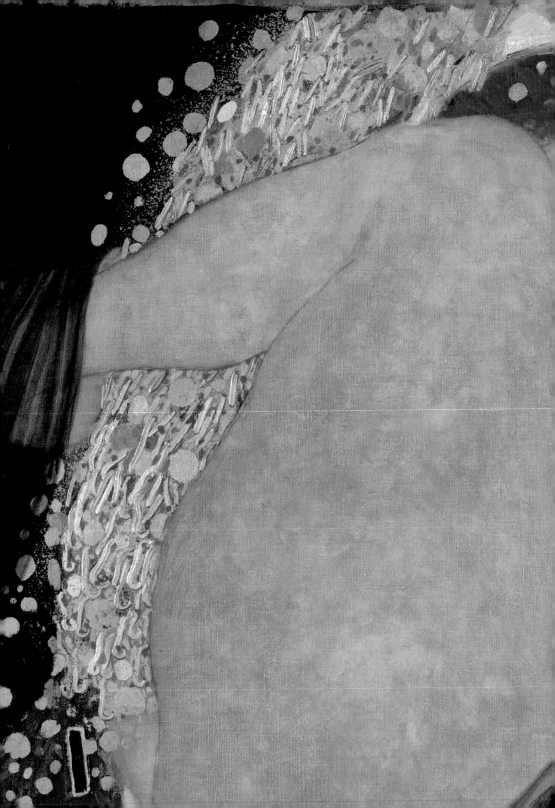

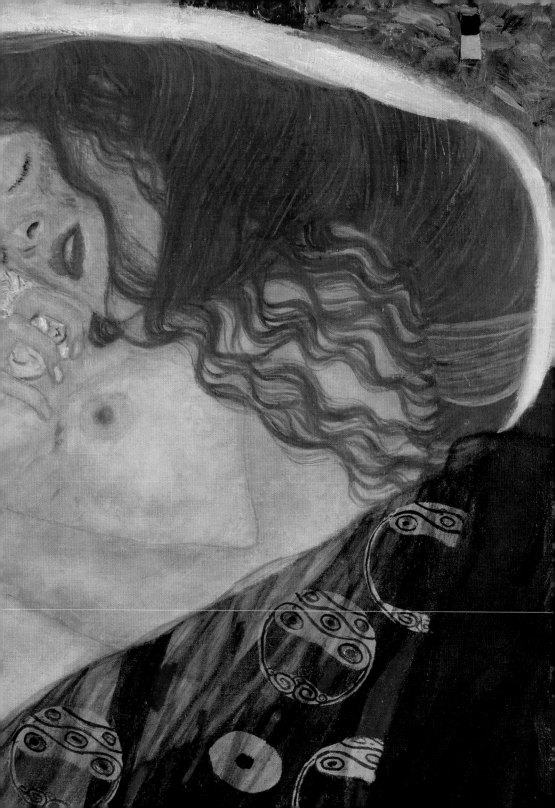

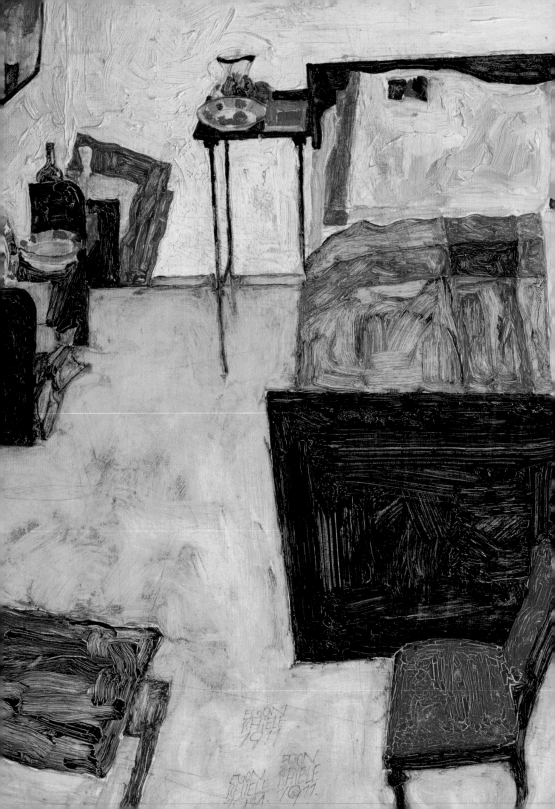

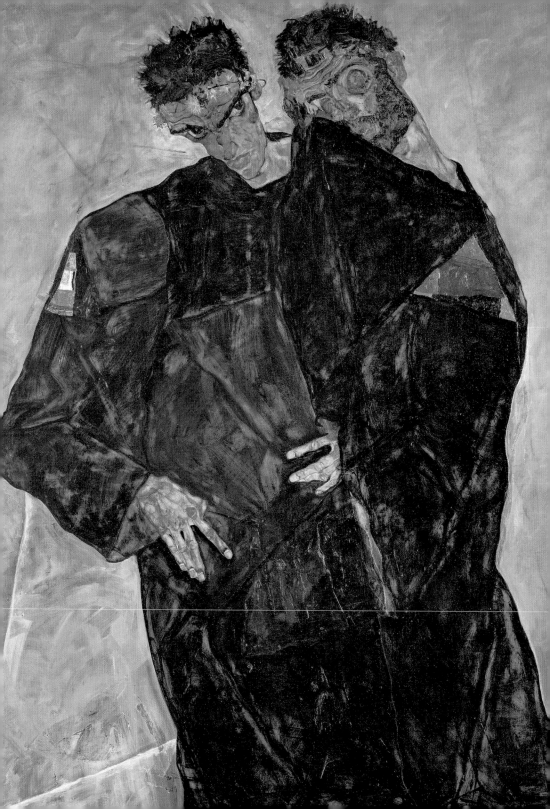

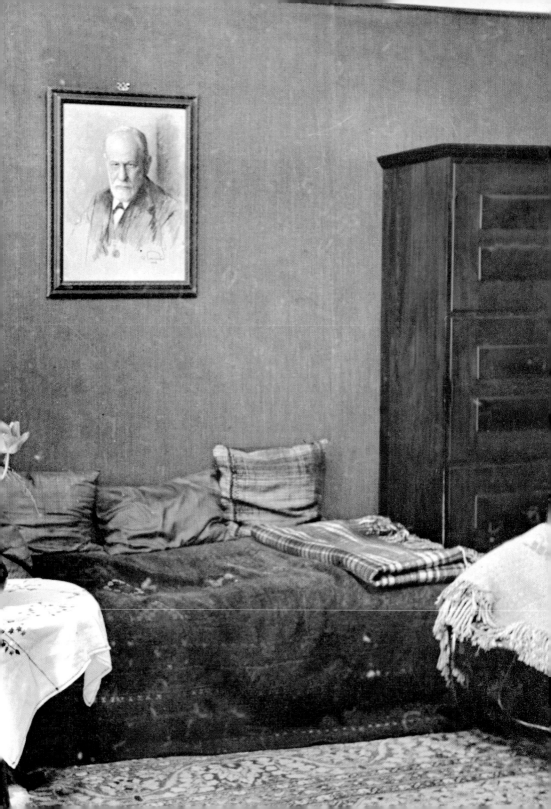

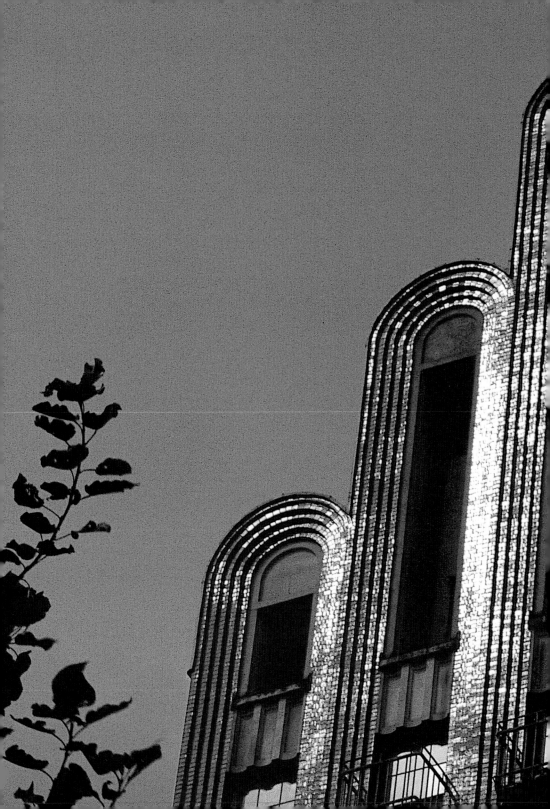

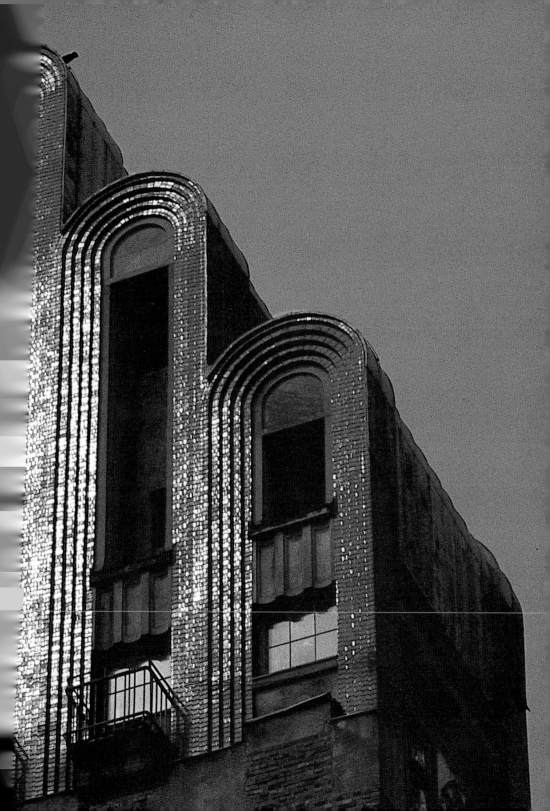

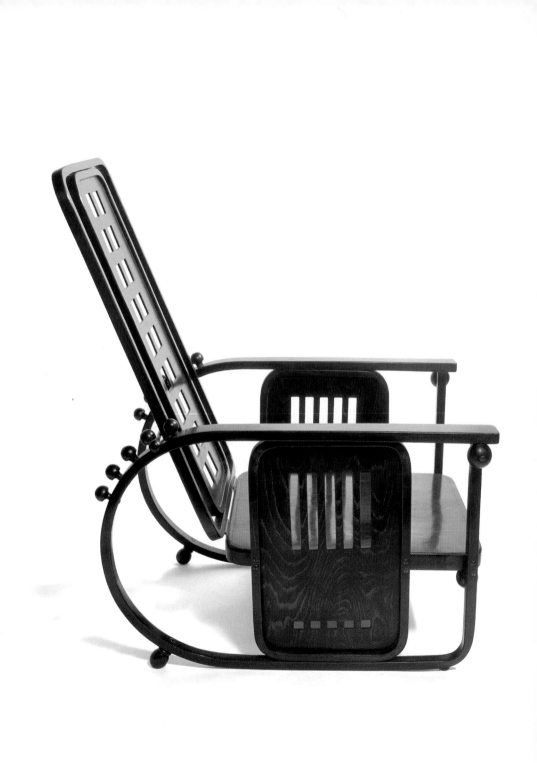

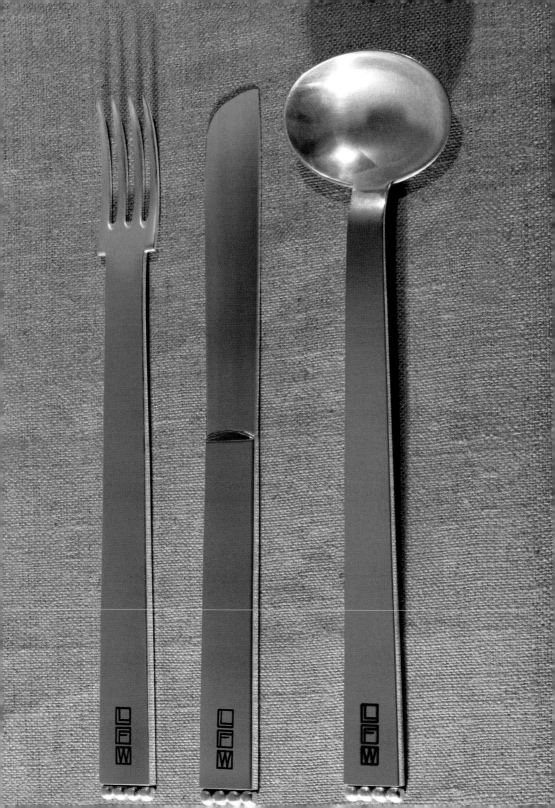

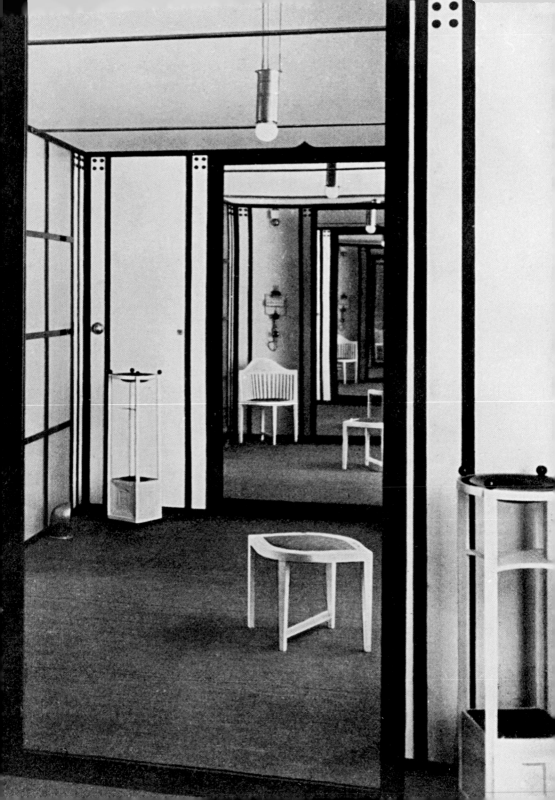

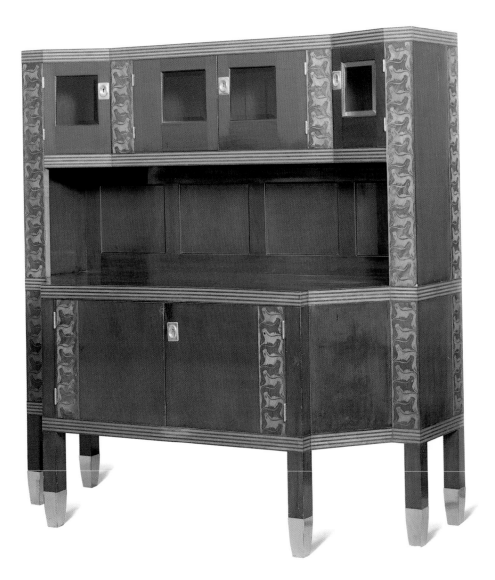

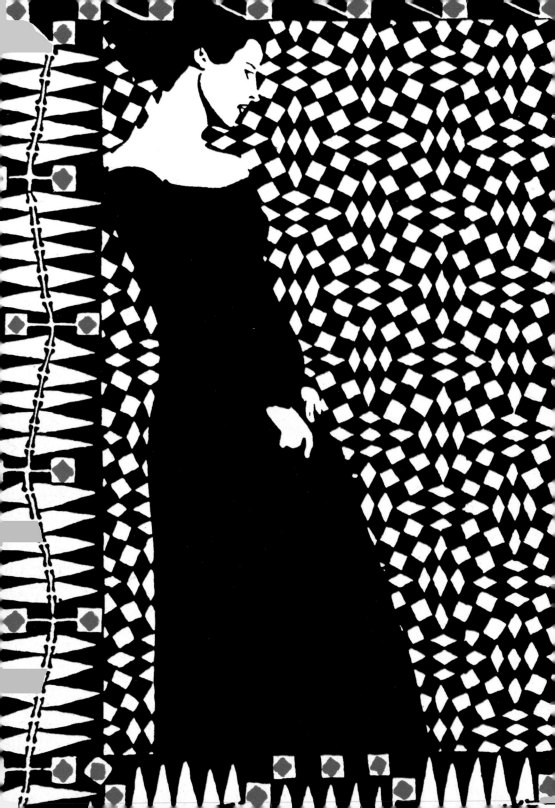

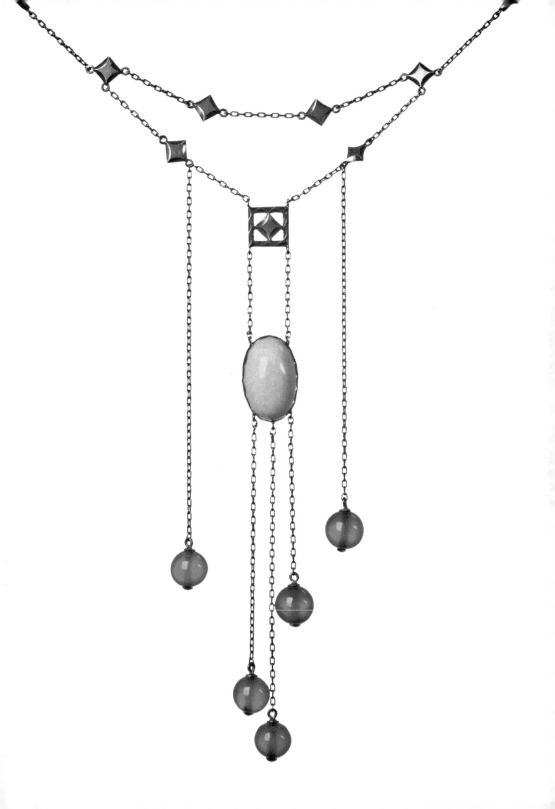

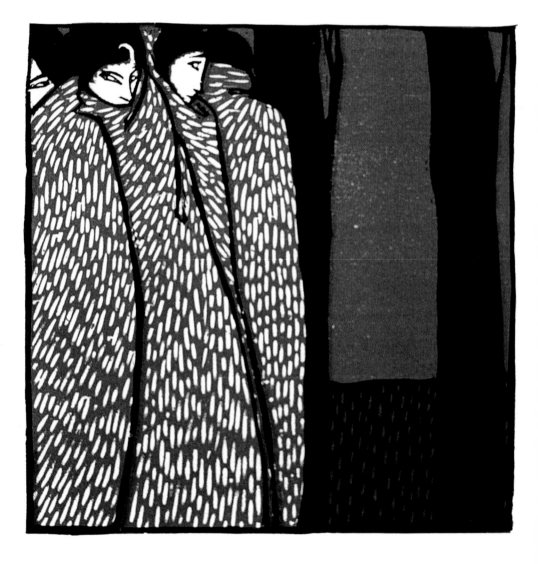

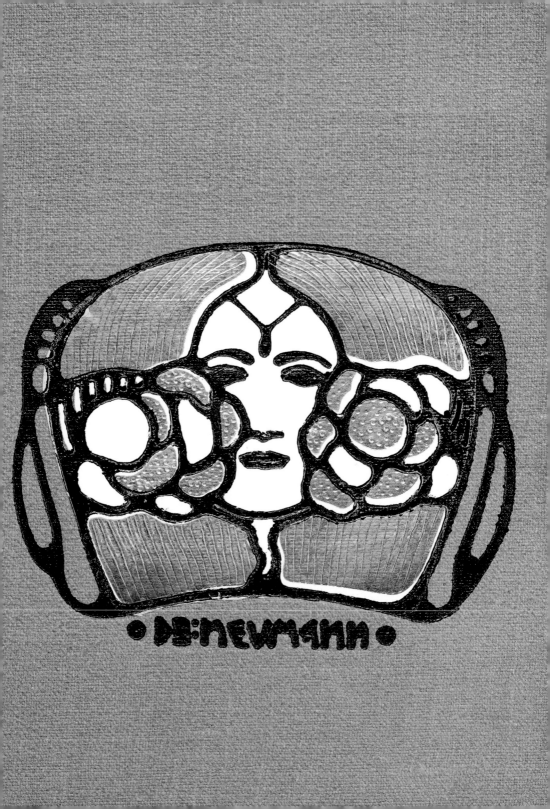

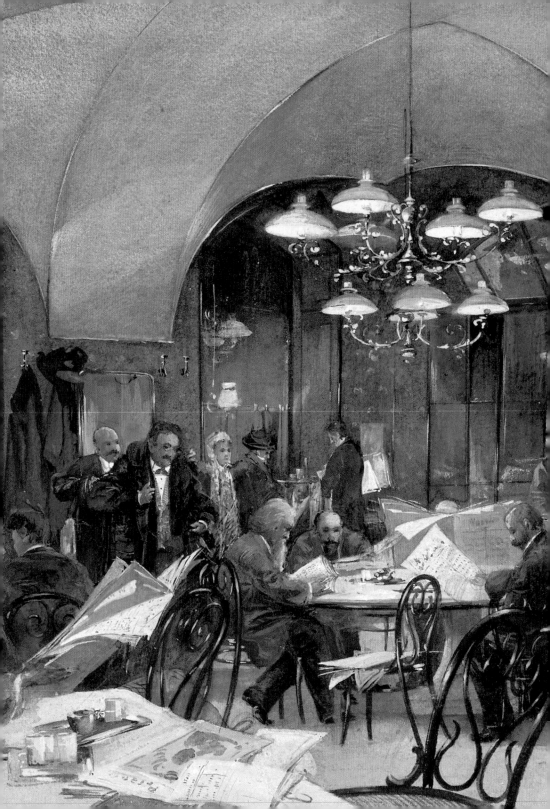

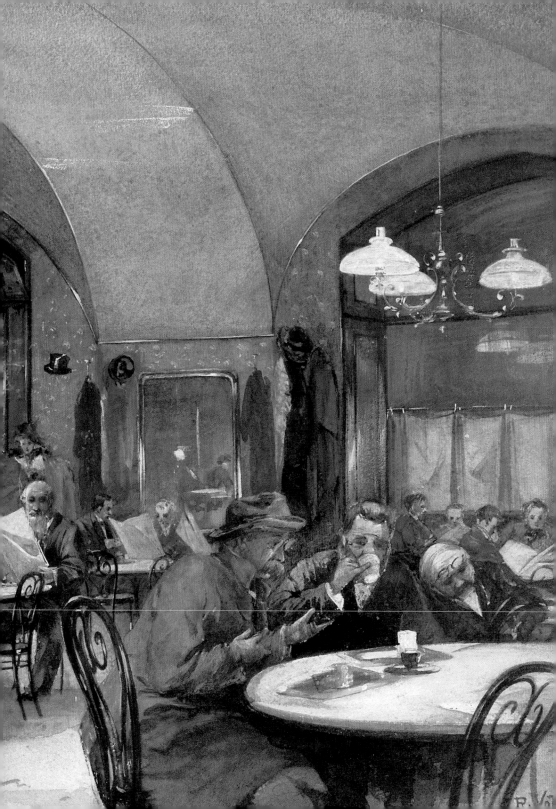

1- LUDWIG WITTGENSTEIN
2- KOLOMAN MOSER
3- STEFAN ZWEIG
4- TRISTAN TZARA
5- GUSTAV KLIMT
6- EGON SCHIELE
7- ARNOLD SCHOENBERG
 (by Egon Schiele, 1917)
8- GUSTAV MAHLER
 (by Emil Orlik, 1912)
9- SIGMUND FREUD
 (by Max Pollack, 1914)

1

2

3

4

5

6 7

8

9

10

11

12

13

14

15

16

17

18

10- OSCAR KOKOSCHKA
11- DAVID JOSEF BACH
(by Oscar Kokoschka, 1920)
12- ARTHUR SCHNITZER
13- RICHARD STRAUSS
14- WILHELM REICH
15- JOSEF HOFFMANN
16- DAGOBERT PECHE
17- THEODOR HERZL
18- OTTO WAGNER

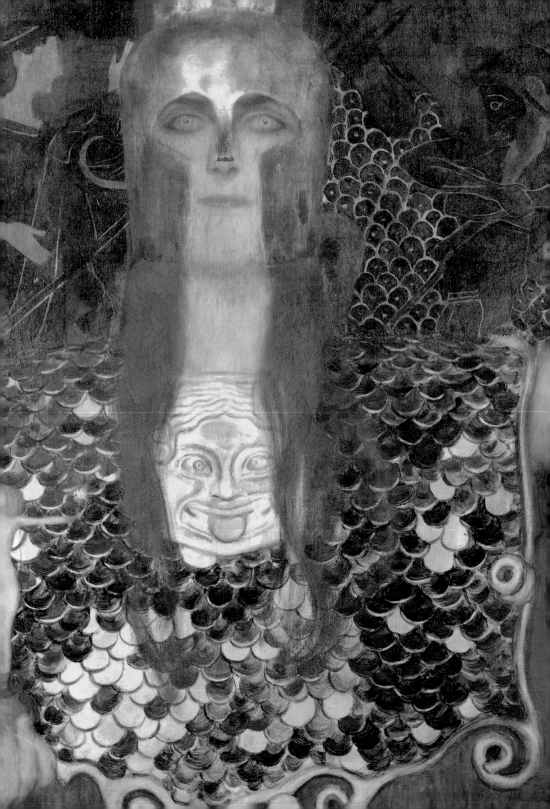

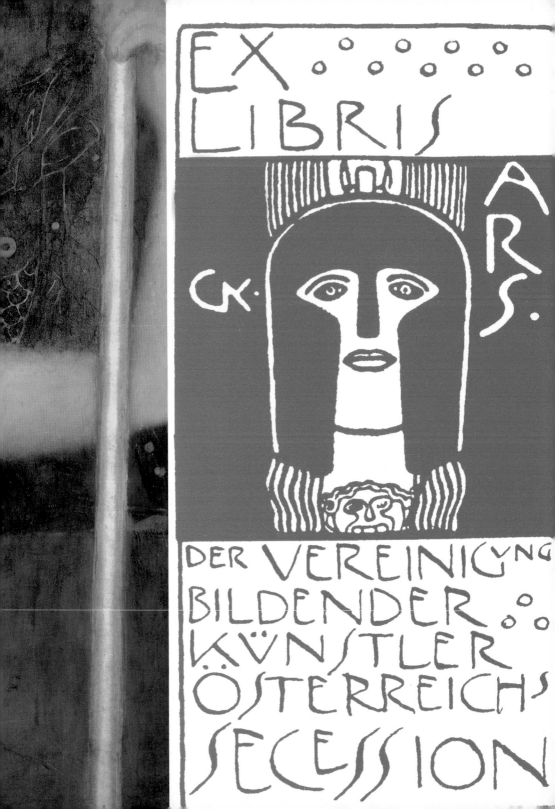

EX ∘ ∘ ∘ ∘ ∘ ∘
∘ ∘ ∘ ∘ ∘
LIBRIS
A
cx. R
s.
DER VEREINIGVNG
BILDENDER ∘∘
KVNSTLER
ÖSTERREICHS
SECESSION

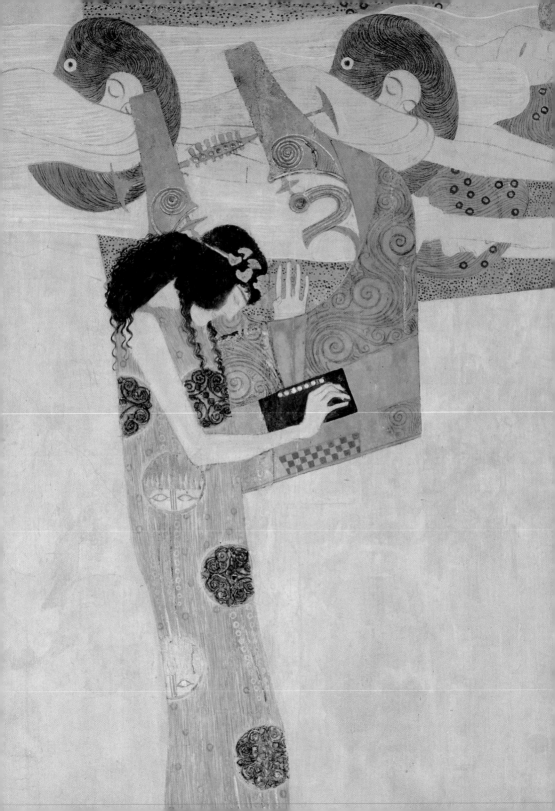

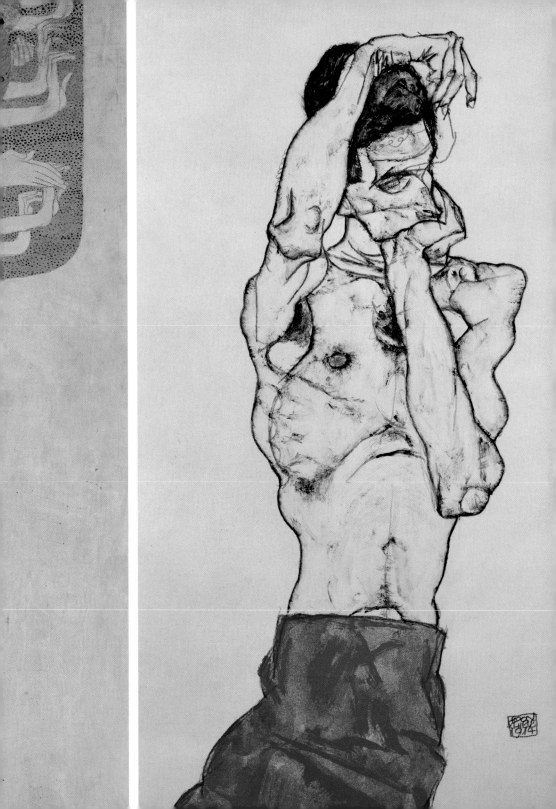

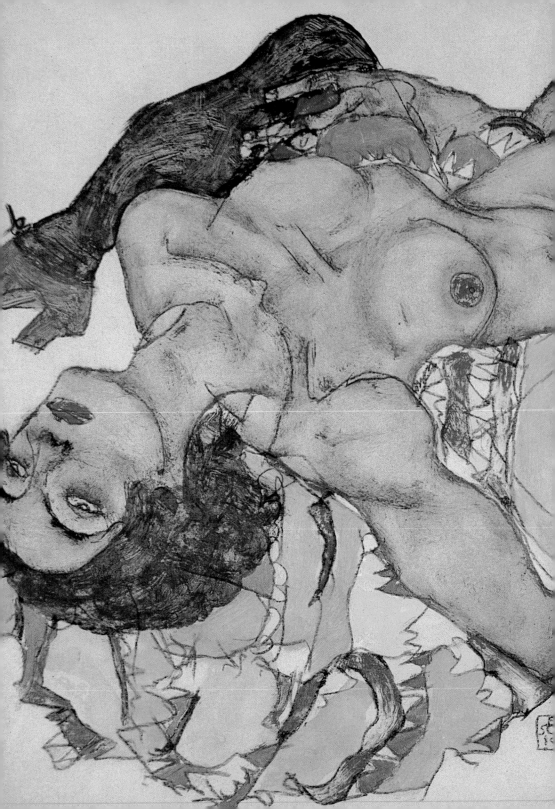

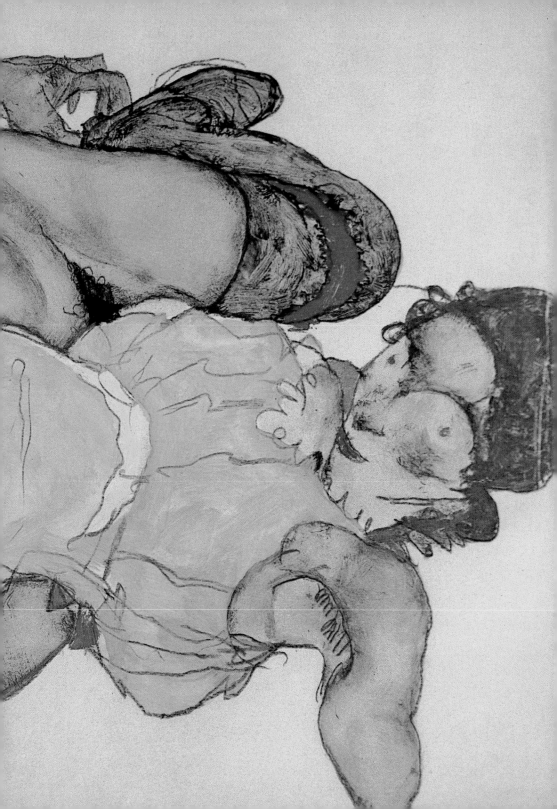

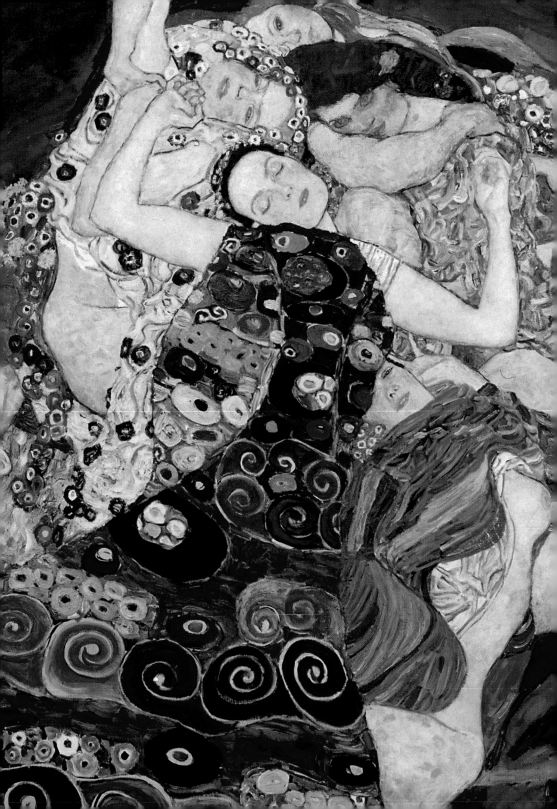

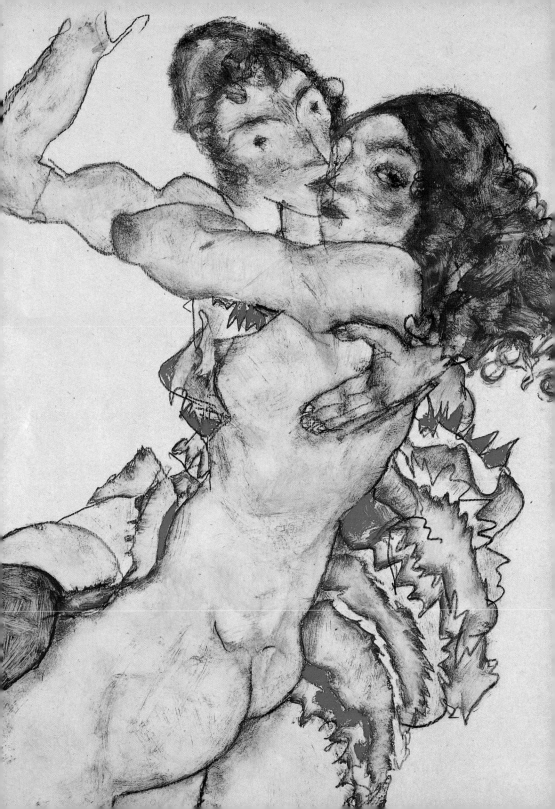

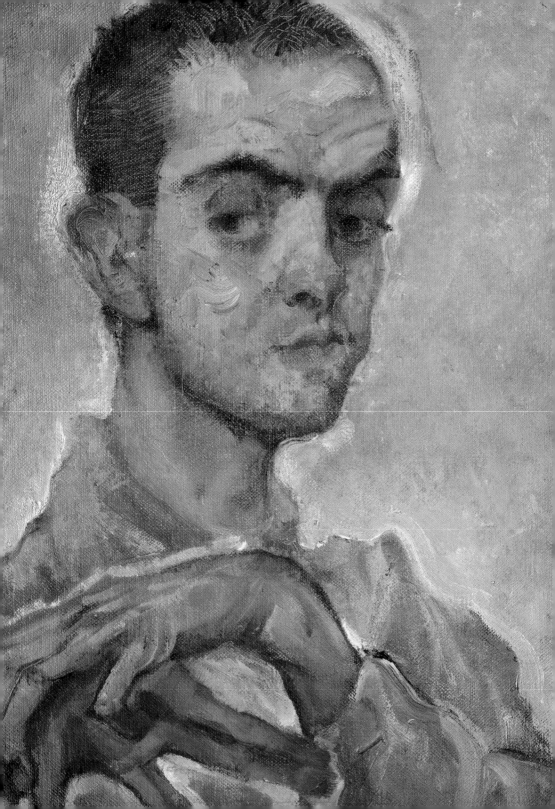

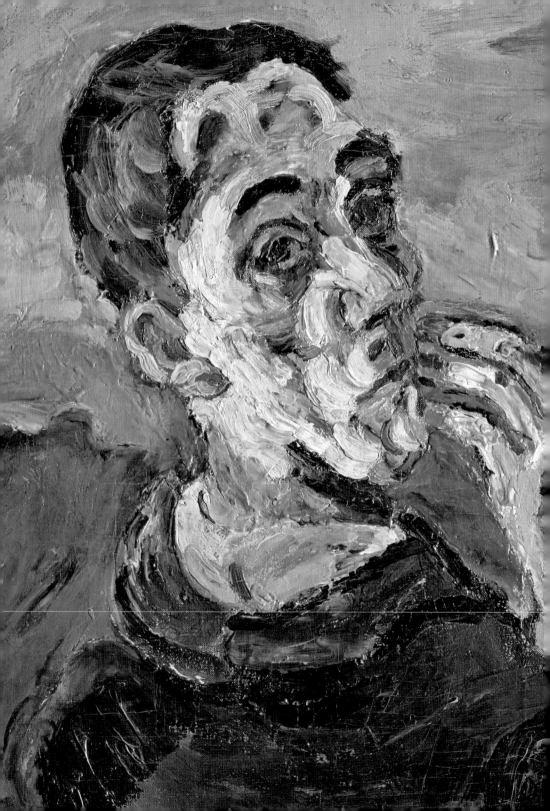

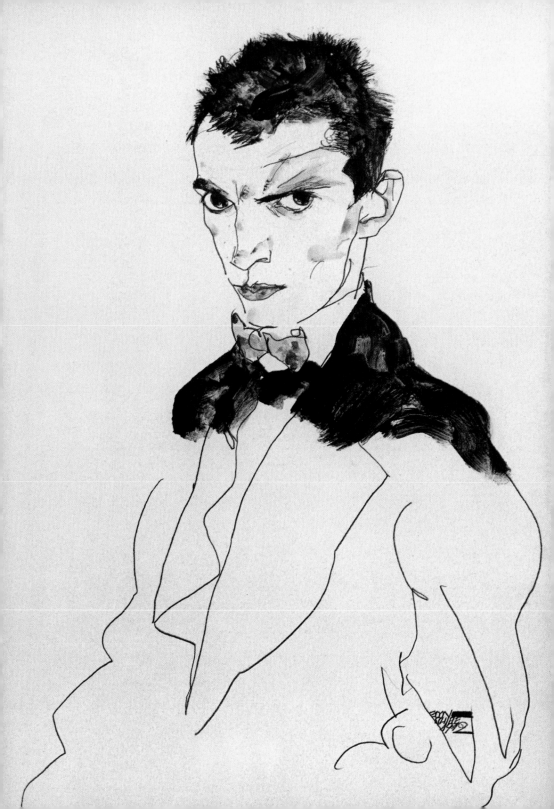

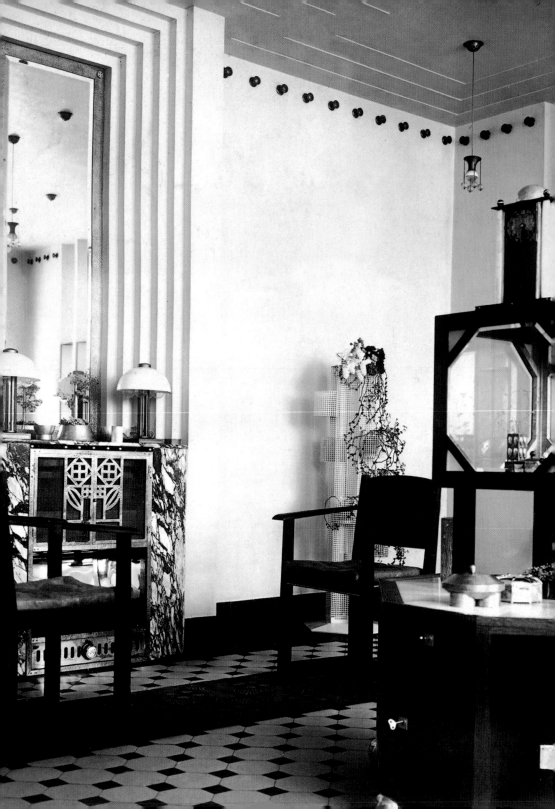

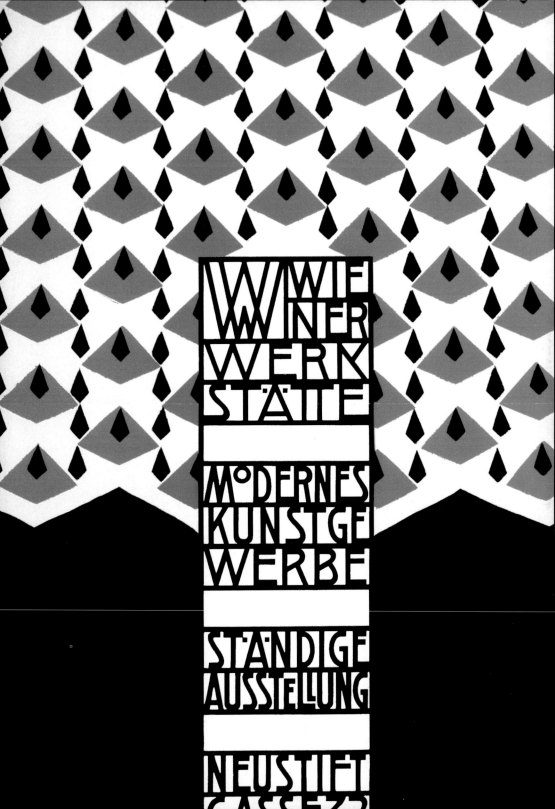

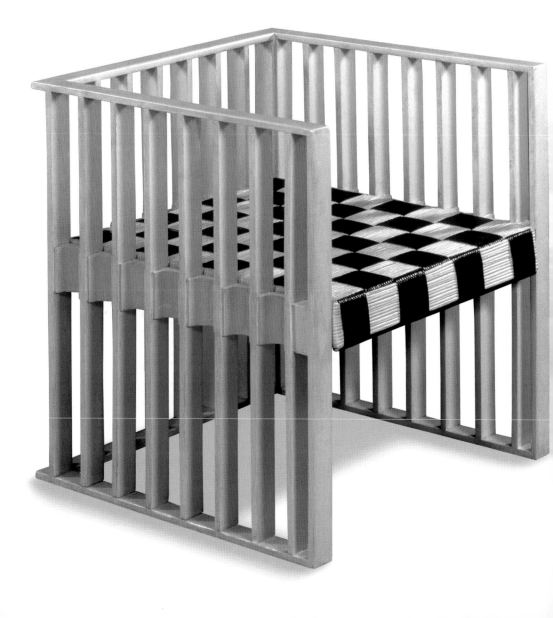

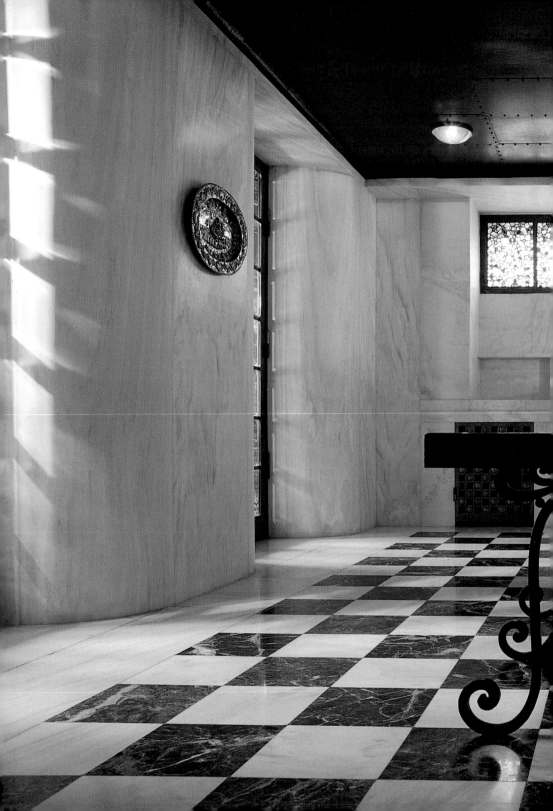

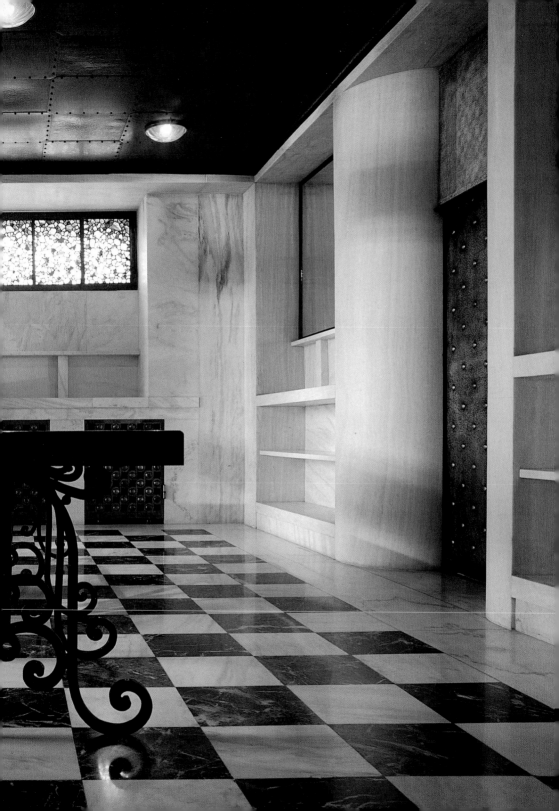

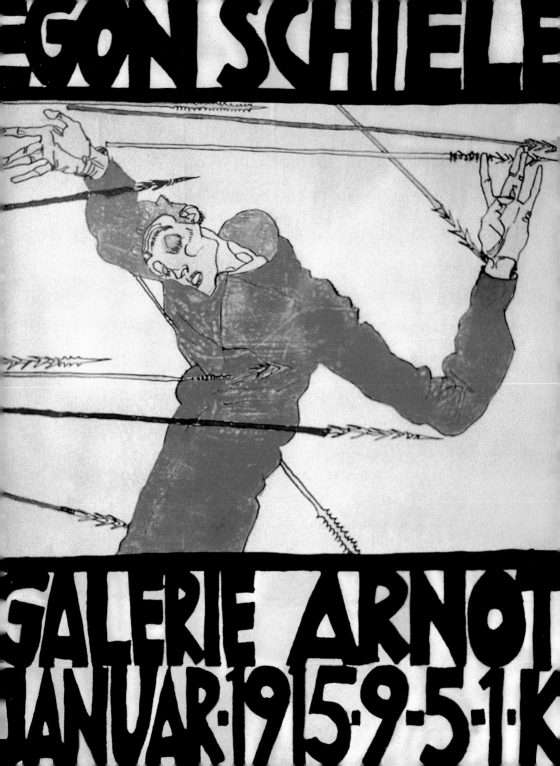

Chronology

1841:	Birth of Otto Wagner in Penzing.
1862:	Birth of Gustav Klimt in Vienna. His father is a silversmith.
1867:	Birth of Joseph Maria Olbrich in Silesia.
1868:	Birth of Koloman Moser in Vienna.
1870:	Birth of Josef Hoffmann in Moravia, and of Adolf Loos in Brno.
1886:	Birth of Oskar Kokoschka in Pöchlarn.
1889:	In the Austrian village of Mayerling, 23 miles southwest of Vienna, the bodies of Archduke Rudolf von Habsburg, son of Franz-Josef I and of Empress Elizabeth, are found lying near that of the Baroness Marie Vetsera.
1890:	Birth of Egon Schiele in Tulln.
1897:	Rudolf Bacher, Josef Hoffmann, Oskar Kokoschka, Carl Moll, Koloman Moser, Joseph Maria Olbrich, Egon Schiele, and some forty other artists founded the "Vienna Secession" under the chairmanship of Gustav Klimt.
1898:	Most of the artists of the Vienna Secession exhibit in the building designed by Joseph Maria Olbrich. Foreign participants include Pierre Bonnard, Edgar Degas, Paul Gauguin, Odilon Redon, Auguste Rodin, Henri de Toulouse-Lautrec, Vincent Van Gogh, the Belgian Symbolists, Walter Crane and Charles Rennie Mackintosh and Edvard Munch. Elizabeth von Wittelsbach, "Sissi", Empress of Austria and Queen of Hungary, is assassinated by the Italian anarchist Luigi Lucheni when walking alongside Lake Geneva.
1899:	The pioneer of functionalist modern architecture, Otto Wagner joins the Secession. Between 1904 and 1906, he builds the Postsparkasse (Post Office Savings Bank) and designs its furniture, and then, in 1907, the Am Steinhof church, both in Vienna, which are enough to establish his credentials as a master of twentieth-century architecture.
1900:	The sixth exhibition of the Vienna Secession, organized by Koloman Moser, is wholly devoted to Japanese art.
1903:	Foundation of the Wiener Werkstätte with Josef Hoffmann, Koloman Moser, and Fritz Wärndorfer.
1905–1911:	Josef Hoffmann starts work in Brussels on a residence for the Belgian magnate Adolf Stoclet. No expense is to be spared. The designers of the Wiener Werkstätte collaborate on an equal footing. This outstanding ensemble has been preserved.
1904:	Gustav Klimt is commissioned to produce mosaics for the dining room of the Stoclet House.
1914:	Franz-Ferdinand von Habsburg, Archduke of Austria, nephew and heir presumptive of Emperor Franz-Joseph I, is assassinated on June 28 at Sarajevo by a Serb. On July 23 Franz-Joseph I issues an ultimatum to Serbia containing an unacceptable clause (that Austria should take part in the investigation into the assassination). On July 28, following Serbia's predictable rejection, Austria declares war on Serbia. Thus begins World War I.
1918 :	Death of Gustav Klimt, Koloman Moser and Egon Schiele. The Secession has run out of steam and the political, economic and aesthetic configuration of postwar Europe is radically different.
1938:	After two decades of decline, the Vienna Secession terminates its activities.

Poster for the Egon Schiele exhibition at Galerie Guido Arnot, Vienna, in 1915.
© Imagno/Austrian Archives.

Theodore Zasche: *The Ringstrasse*, 1900. Color lithograph, private collection, Vienna. (In the foreground) Gustav Mahler, Karl Spitzer, Arnold Rose, Hansi Niese, Ludwig Bosendorfer, Egon Fürstenberg, Erzherzog Eurgen, Selma Kurz, Leo Slezak, Ludwig Baumann, Eduard Potzl, Otto Wagner, Philipp Haas, and Georg Reimers. This road around Old Vienna lined with imposing civic buildings was where the Viennese elite came to see and be seen in the late nineteenth century. © Imagno/Austrian Archives.

Otto Wagner: Karlsplatz metro station, Vienna, 1899. The great pioneer of modern architecture, involved with the Secession from the outset, Wagner made highly ornamental use of steel and glass to build the stations for what was itself a very modern means of transport. This was ten years before Hector Guimard's famous Parisian stations helped earn Art Nouveau the sobriquet of "style métro." © Keiichi Tahara.

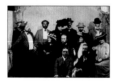

Otto Wagner: the Kaiserbad lock on the Donaukanal, Vienna, 1904–06. There is not a trace of historicism in this functional building which retains a decorative quality based on the use of simple forms, which distinguishes the Vienna Secession from Art Nouveau elsewhere in Europe. © Keiichi Tahara.

Group photograph from the time of the foundation of the Vienna Secession (on May 25, 1897), with (from left): J. Hoffmann, hidden by C. Moll, G. Klimt, A. Roller, K. Moser and, in front of A. Roller, F. Wärndorfer (c. 1898). Intellectual disagreement within the very official Künstlerhaus drove Klimt and his sympathizers to found this group which was attentive to all the new trends in art, and that itself generated a wholly unique style. © Imagno/NB.

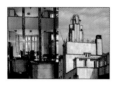

Josef Hoffmann: entrance hall of the Stoclet House, Brussels, 1905–11. © Imagno/Austrian Archives. **Josef Hoffmann**: the tower of the Stoclet House. The tower of this imposing private home is one of the few examples of collaboration between the main members of the Secession to remain intact. It was the wish of railways magnate Adolf Stoclet (1871–1949) that the artists of the Wiener Werkstätte should express themselves with total freedom. © Angelo Hormak/Corbis.

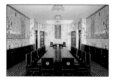

Josef Hoffmann: interior of the Stoclet House, Brussels, 1905–11. In addition to Klimt's decoration—notably his curl pattern mosaics—the dining room had superb marble veneer and furniture specially designed by Josef Hoffmann. © Imagno/Austrian Archives.

Gustav Klimt: *Danae*, 1907–08. Oil on canvas, 30$^{1/3}$ x 35", Hans Dichand collection, Vienna. Initially pre-Raphaelite and Orientalist in style, Klimt's art is characterized by a languorous eroticism which entwines bodies with flat ornamental motifs inspired, among others, by Persian, Greek and Japanese art. © Akg-images/Erich Lessing.

Egon Schiele: (left) *Schiele's Room in Neulengbach*, 1911. Oil on canvas, 5³/⁴ x 12¹/⁵", Wien Museum, Vienna; (right) *Hermits, self-portrait with Gustav Klimt*, 1912, oil on canvas, 71¹/⁴ x 71¹/⁴", Leopold Museum, Vienna. © Akg-images/Erich Lessing. A precocious genius, Schiele entered Vienna's school of fine arts at age 16 and met Klimt the following year. Their friendship was built on mutual fascination. Both men died in 1918.

The house where Sigmund Freud lived (left) from 1891 to 1938 at 19 Berggasse, Vienna 9. © All rights reserved; (right) **his consulting room** in 1938 © Imagno/Austrian Archives/Edmund Engelman. Born in Freiberg in 1856, the founding father of psychoanalysis had his first practice on the Ringstrasse, in a building nicknamed "the field of expiation" because it was built on the ruins of a theatre that burned down in 1881, causing many deaths.

Koloman Moser: lithograph, 1901, 10¹/⁴ x 11⁴/⁵", published in *The Springwell* (a Viennese journal edited by Martin Gerlach). © Imagno/Austrian Archives.
Egon Shiele: *Portrait of Max Oppenheimer*, 1910. Black chalk, ink, and watercolor on paper, 17³/⁴ x 11³/⁴", Graphische Sammlung Albertina, Vienna. The friend of Schiele and son of the writer Ludwig Oppenheimer became the portraitist of Viennese artists before his exile in the United States. © Nimatallah/Art Resource, NY.

Oskar Kokoschka: *The Dreaming Boys*, 1908. Lithograph, 10¹/⁷ x 11¹/²", Wien Museum. Working for the Wiener Werkstätte (posters, postcards, vignettes, monograms, fans, etc.) the future master of European Expressionism published and illustrated his first book, a bitter tale of puberty, under the same title. © Akg-images/Erich Lessing.
Josef Hoffmann: basket, 1905, Wiener Werkstätte. © Imagno/Austrian Archives.

Joseph Maria Olbrich: the Mathildenhöhe artists' colony, 1899, Darmstadt, Germany. The assistant of Otto Wagner between 1893 and 1898, a member of the Secession and designer of the famous Sezession building, the architect was able to develop his boldly modernist style even further when he built this extension for the Viennese movement. © Keiichi Tahara.

Josef Hoffmann: A champion of the integration of the crafts into one great movement, this architect created one of the strangest chairs of the twentieth century, the mahogany *Sitzmachine* (left), or "sitting machine," with an adjustable back, 1905. © Imagno/Austrian Archives. At the same time (right), he designed this elegant set of silver cutlery (1904–08) for Lilly and Fritz Wärndorfer, and produced by the Wiener Werkstätte. © Imagno/Austrian Archives.

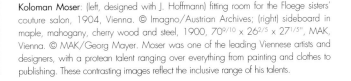

Koloman Moser: (left, designed with J. Hoffmann) fitting room for the Floege sisters' couture salon, 1904, Vienna. © Imagno/Austrian Archives; (right) sideboard in maple, mahogany, cherry wood and steel, 1900, 70⁹/¹⁰ x 26²/⁵ x 27¹/⁵", MAK, Vienna. © MAK/Georg Mayer. Moser was one of the leading Viennese artists and designers, with a protean talent ranging over everything from painting and clothes to publishing. These contrasting images reflect the inclusive range of his talents.

Gustav Klimt: (left) with Emilie Floege in the garden outside his studio in Vienna, 1905–06. © Moriz Nähr/All rights reserved; (right) *Portrait of a Lady (Maria Munk)*, 1917–18. Oil on canvas, 26²/⁵ x 22'', Lentos Kunstmuseum, Linz. © Akg-image/Erich Lessing. A dominant figure of the Secession, mysterious yet popular with the public, this painter expressed both the grace of fin-de-siècle femininity and the morbid effervescence of the Viennese apocalypse.

Koloman Moser: *The Duchess and the Page* (detail), 1901, 7³/⁶ x 7¹/¹⁰'', Vienna. Illustration for the poem by Rainer Maria Rilke, *Vorfruehling*, published in *Ver sacrum* ("Sacred Spring"). Begun in 1898, the texts and illustrations published in this quarterly review spirit until its termination in 1903 epitomized the best of the Viennese. © Imagno/Austrian Archives. **Gustav Klimt**: (Wiener Werkstätte), necklace given to Emilie Floege in 1903. © Imagno/Austrian Archives.

Koloman Moser: (left) illustration for the magazine *Ver sacrum*, 1902. © Imagno/Austrian Archives; (right) bookplate for Doctor Neumann, print on canvas, c. 1905. © Imagno/Austrian Archives. Graphic art and binding were two important aesthetic concerns for Moser, who was trained at the Museum Fuer Angewandte Kunst in Vienna between 1892 and 1895. However, the final years of his life, between 1910 and 1918, were devoted to painting.

Reinhold Völkel, *In the Cafe Griensteidl in Vienna*, 1896. Watercolor, Historisches Museum der Stadt Wien, Vienna. Places of entertainment and exchange, of commerce and rapprochement, the big cafés played a strategic role in the development of Viennese artistic and literary life, as chronicled by Peter Altenberg in his short sketches. © Akg-images/Erich Lessing.

Gustav Klimt: *Pallas Athene*, 1898. Oil on canvas, 29¹/² x 29¹/²'', Wien Museum. Rather like Freud with his theories, Klimt liked to use ancient mythology to express his concerns. Thus, in his paintings, Oedipus and his complex are found alongside the wisdom of a helmeted Minerva. © Akg-images/Erich Lessing.
Vienna Secession bookplate designed by Gustav Klimt, c. 1900. © Imagno/Austrian Archives.

Gustav Klimt: *Beethoven Frieze* (detail), 1902, Oesterreichische Galerie, Vienna. One of Klimt's three most important commissions, this fresco constitutes a passionate paean to the redeeming artist figure, seen as a kind of secular saint persecuted by the mediocrity of everyday life. © Imagno/Austrian Archives. **Egon Schiele**: *Standing Male Nude with a Red Loincloth*, 1914, gouache, watercolor, and pencil, 18⁹/¹⁰ x 12³/⁵'', Graphische Sammlung Albertina, Vienna. © Akg-images/Erich Lessing.

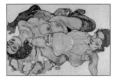

Egon Schiele: *Two Girls Lying Entwined*, 1915. Pencil and gouache, 13 x 19³/⁵", Graphische Sammlung Albertina, Vienna. Painted three years before his death, this group clearly expresses the voluptuous sensuality, fevered agitation and introspective monomania that shocked the contemporaries of this visionary painter. © Imagno/Austrian Archives.

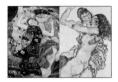

Gustav Klimt: *The Virgin*, 1912–13. Oil on canvas, 74⁴/⁵ x 78³/⁴", Narodni Galerie, Prague. Klimt was one of that rare breed of men who help their fellows rather than hinder them. He met Schiele in 1909 and was constantly supportive of his non-academic art. © Akg-images.
Egon Schiele: *Two Girls Embracing*, 1915, pencil and distemper on paper, Szepmüveszeti Muzeum, Budapest. © Courtesy Szepmüveszeti Muzeum, Budapest.

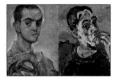

Max Oppenheimer (left) *Portrait of Egon Schiele*,1911. Oil on canvas, 18¹/² x 17³/⁴", Wien Museum. © Akg-images/Erich Lessing) and (right) Oskar Kokoschka, *Self-portrait*, 1918, Oil on canvas, 329 x 247¹/⁴", Leopold Museum. © Akg-image/Erich Lessing): these two young members of the Viennese avant-garde were among the rare artists to survive it and continue to work after World War II.

Koloman Moser, geometric carpet design for Backhausen & Söhne, 1902, Vienna. © Corbis/Austrian Archives.
Egon Schiele, *Self-portrait*, 1912. Pencil, watercolor, and distemper on paper, 18¹/³ x 12¹/²". Private collection. © Corbis/Austrian Archives.

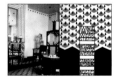

Josef Hoffmann: (left) Wiener Werkstätte showroom (Neustiftgasse 32-34, Vienna 7, 1905. © Imagno/Austrian Archives) and, (right) poster for the workshops of the Wiener Werkstätte (1905. © Corbis/Austrian Archives).

Koloman Moser: (left) bookmark for Galerie Miethke (1904, Vienna. © Imagno/Austrian Archives) and (right) chair for the entrance hall of the sanatorium at Purkersdorf (1901, painted maple wood and checkered vinyl, 28¹/³ x 26 x 25¹/⁵". © Sotheby's/Akg-images).

Adolf Loos (1870-1933), Villa Karma, 1906, Tour-de-Peilz (Switzerland). This champion of an architecture freed of ornamental certitudes and precursor of the functionalists designed many buildings whose spare forms, exemplified by this vestibule, would prove highly influential. © Keiichi Tahara.

Bibliography

Gustav Klimt, Modernism in the Making, edited by Colin B. Bailey, New York; Harry N Abrams, 2001.

Gustav Klimt, Erotic Sketches; Prestel Publishing, 2005.

Peter Vergo, Art in Vienna 1898–1918, London; Phaidon, 1993.

Nikolaus Pevsner, The Sources of Modern Architecture and Design; Thames & Hudson, 1985.

Vienna 1900: Art, Architecture & Design, New York; Museum of Modern Art, 1986.

Carl E. Schorske, Fin-De-Siècle Vienna: Politics and Culture; Vintage, 1980.

Telegrams of the Soul: Selected Prose of Peter Altenberg; Archipelago Books, 2005.

Waltraud Neuwirth, Wiener Werkstätte: Avantgarde, Art Deco; Industrial Design, 1984.

Acknowledgments

The publisher would like to thank the whole team of the Imagno agency, and the Wien Museum, the Museum of Fine Art in Budapest, Thomas Matyk from the MAK, and the agencies Art Resource, Bridgeman Art Library, Corbis, and RMN.